How to Draw
Mountain Animals
In Simple Steps

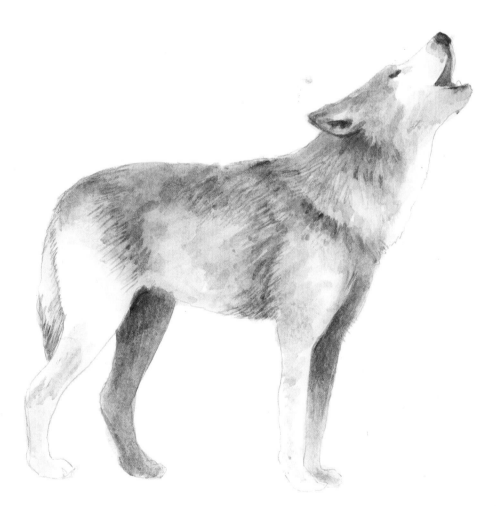

First published in 2021

Search Press Limited
Wellwood, North Farm Road,
Tunbridge Wells, Kent TN2 3DR

ISBN: 978-1-78221-888-3
eBook ISBN: 978-1-78126-884-1

You are invited to visit the author's website:
www.susiehodge.com

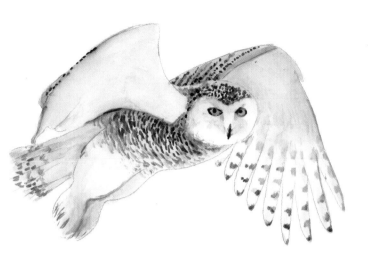

Dedication

*To you, the reader;
wishing you success and happiness.*

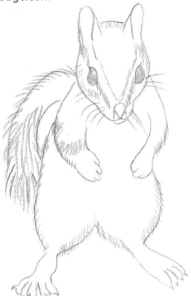

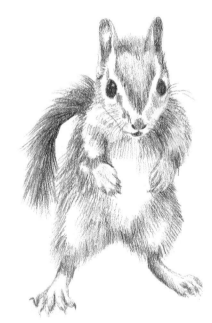

Illustrations

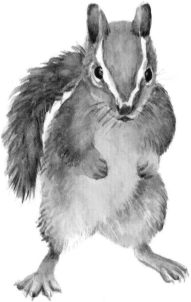

How to Draw

Mountain Animals

In Simple Steps

Susie Hodge

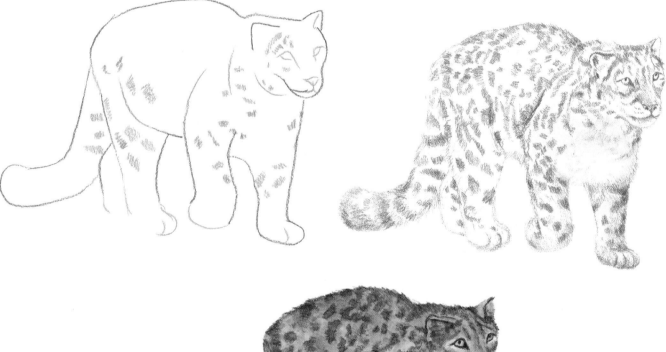

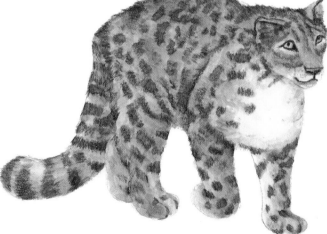

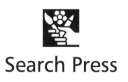

Search Press

Introduction

From lush foothills to steep crags, mountain landscapes experience many weather changes and are the habitat of various animals and birds. High above the tree line, only the hardiest creatures can live; temperatures are cold, oxygen is scarce and the sun is harsh. Temperate mountains, in Europe, Central Asia and North and South America, are usually cold all year, while tropical mountains, in Africa, Southeast Asia and South America, are warmer. Many species of hoofed and herbivorous mammals such as goats, deer, sheep and llamas have adapted to living in some mountains and they attract large predators, including bears, cougars and mountain lions.

Throughout this book, I show you how to draw a variety of mountain animals and birds, including a bald eagle, an antelope, an Andean mountain cat, a dhole and a beaver. It is a visual instruction book, so there are no words. Each animal is drawn in the first four steps using pink and blue marks, to make each stage easy to follow, and every animal is drawn in roughly the same sequence. In step one, basic shapes are drawn in pink, summarizing the animal's form. Step two shows what was drawn in step one, now in blue, with new marks added in pink. These new marks begin to create a more lifelike animal, for instance, shaping the neck, back, legs and head. In step three, more details are added, such as facial features, and in step four, textures and tonal contrasts are developed. The fifth stage shows the completed drawing in graphite pencil, showing texture, tone, structure, facial features and other details, including something of the animal's character. Finally, there is a watercolour of each animal in its natural colours to give you further ideas of what you can do.

When you follow the stages to create your own drawings, use a pencil, not the pink and blue coloured pencils that I have used, as they are there only to show you how to build up to each drawing. Try using a B, 2B, 3B or a range of graphite pencils. The higher the number before B, the softer and darker your marks will be. H pencils are generally too hard for this sort of drawing, although an HB will be fine, as these are just a bit harder than B pencils. You could also or alternatively use a ballpoint, felt-tip or technical pen, either from the start for the whole drawing, or over your pencil lines. When you feel more confident about drawing, you might want to try using colour. I have used watercolour, but you may prefer to use coloured pencils, pastels or acrylic paints for example. All these materials have the potential to create great effects.

I hope you draw all the animals in this book and then go on to draw more of your own. If you always use the simple construction method as I have shown, you will attain the correct proportions. To do this, before you draw, look at the animal you are drawing and visualize its basic shapes and proportions – for instance, the size of the head compared to the body; the length of the legs in relation to the length of the head and so on. You will soon become confident in drawing and will develop your own style, which in turn will give you years of pleasure.

Happy drawing!

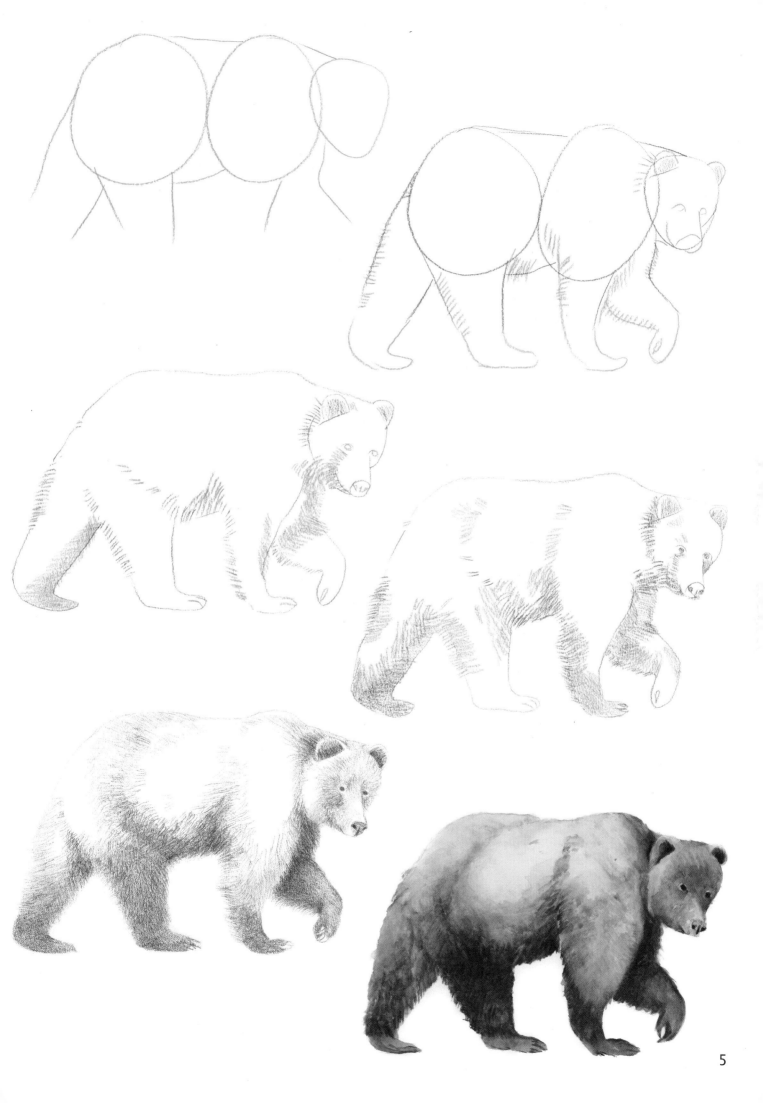

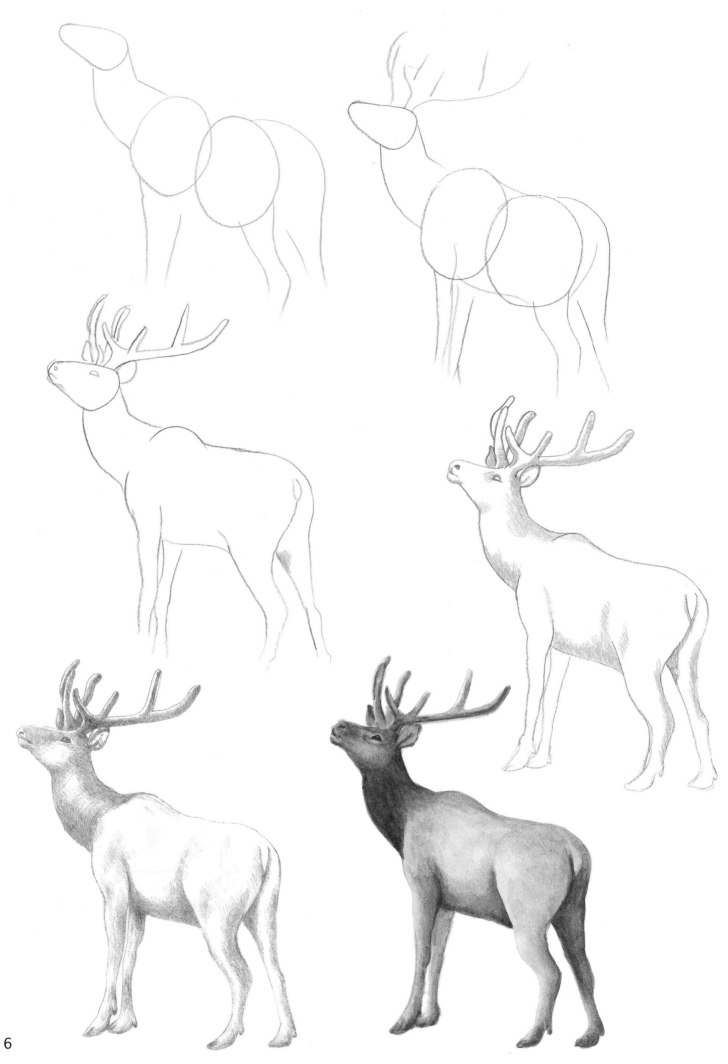

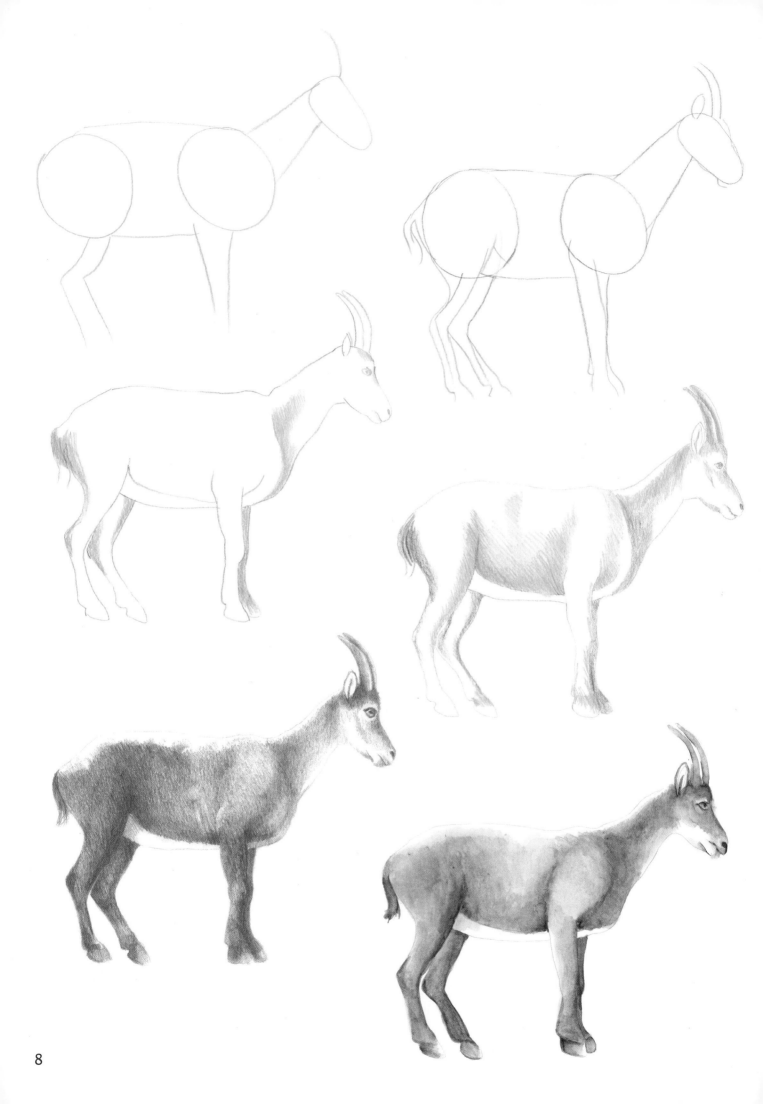

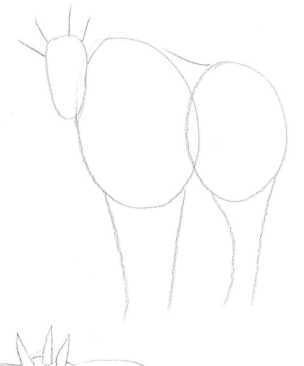
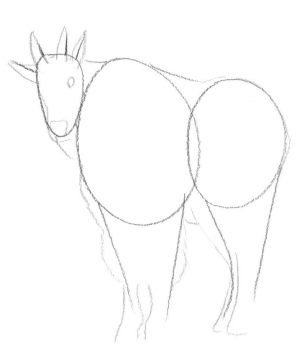
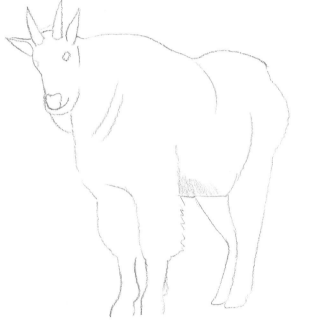
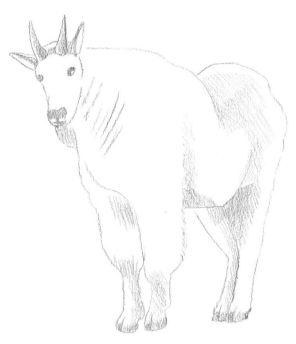
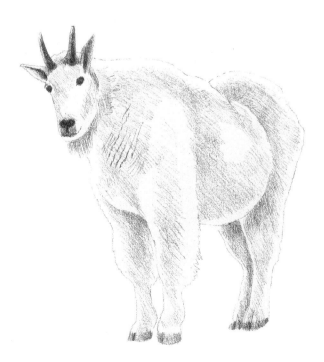
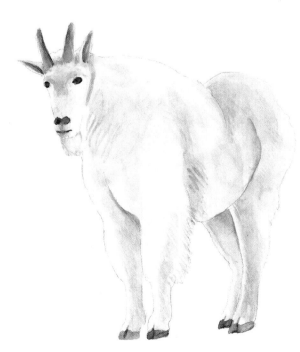

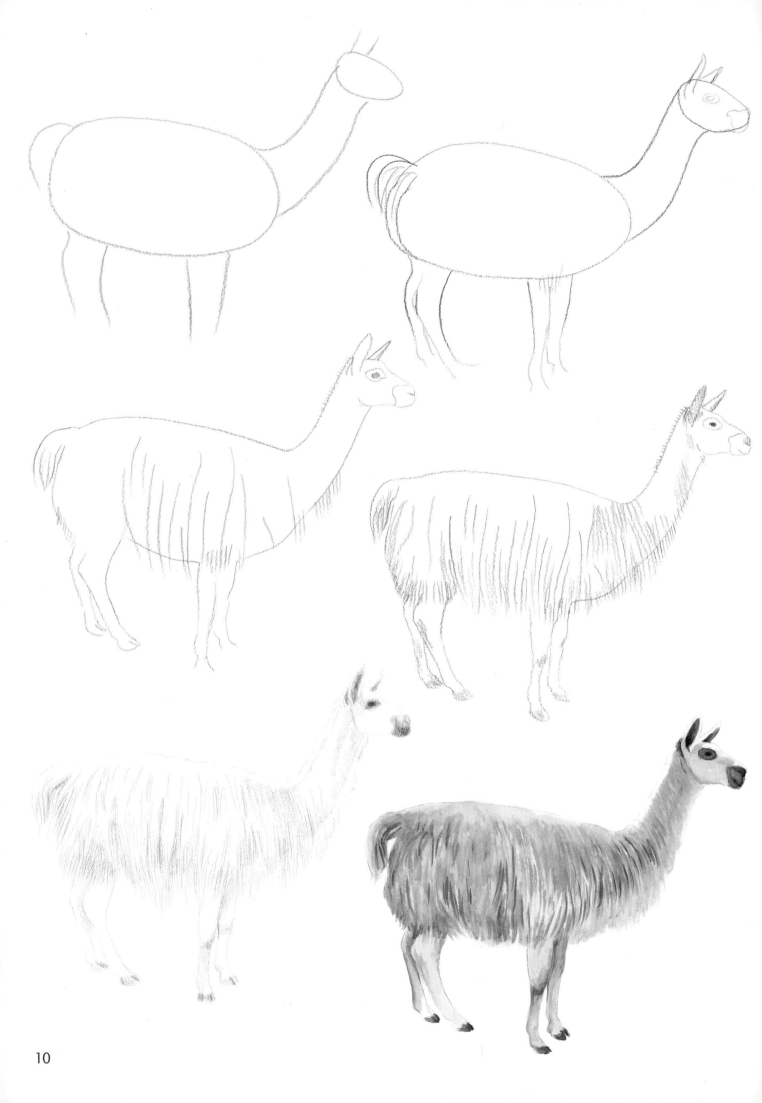

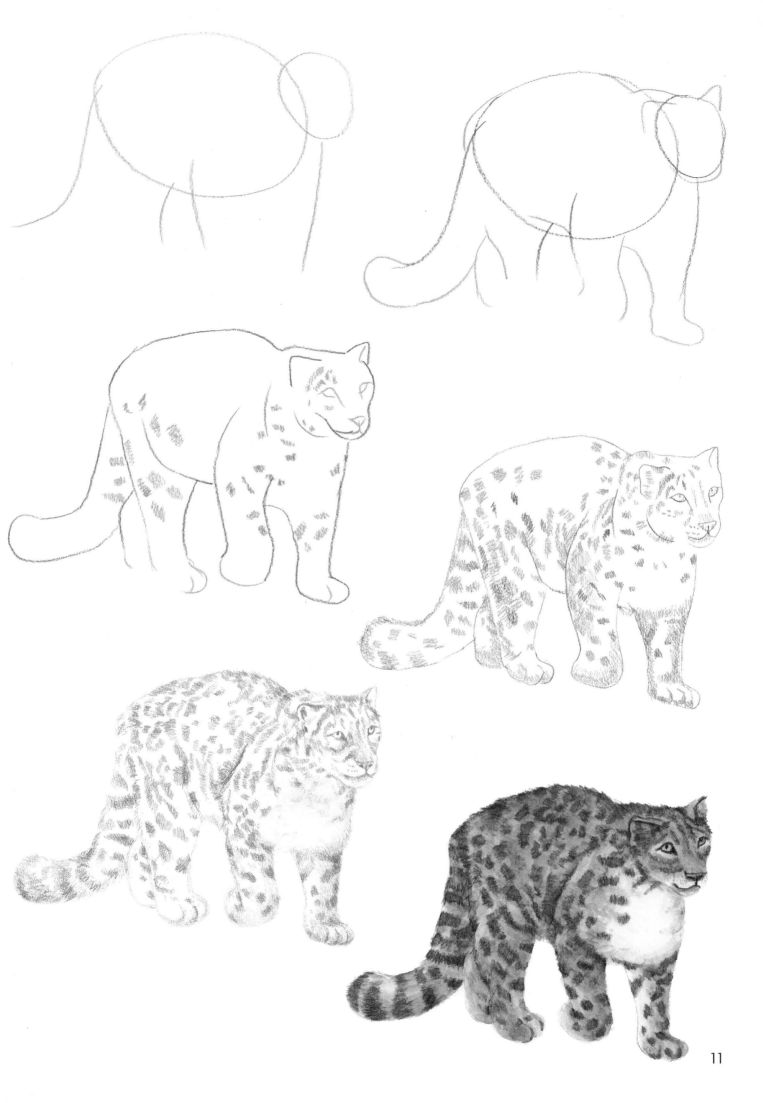

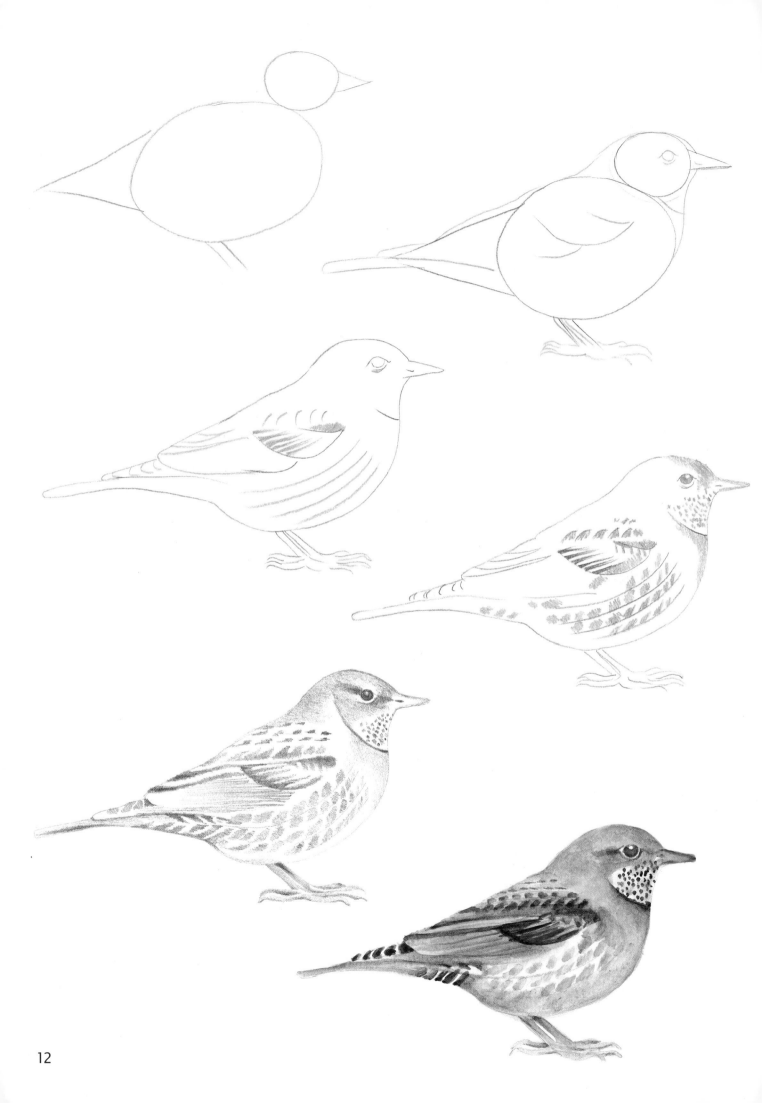

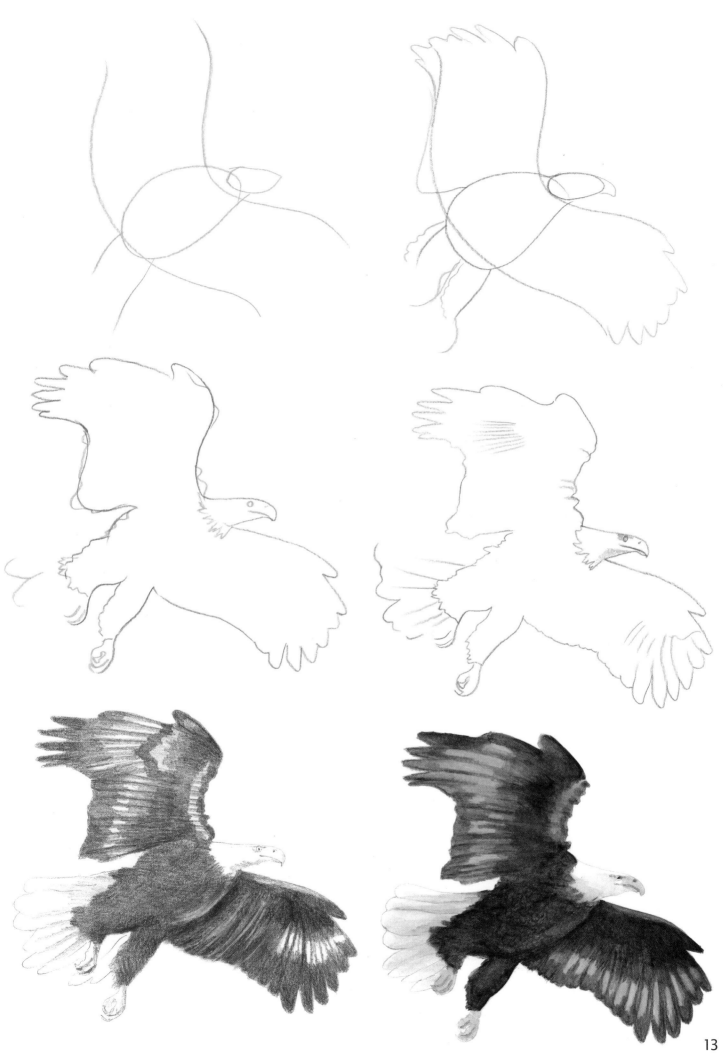

13

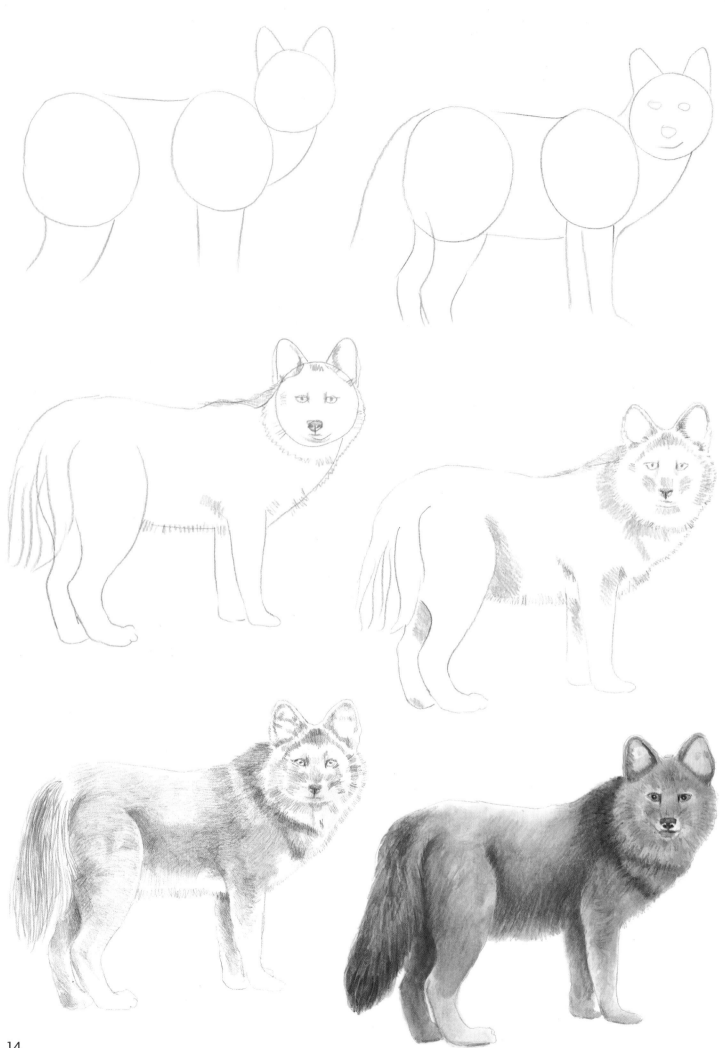

14

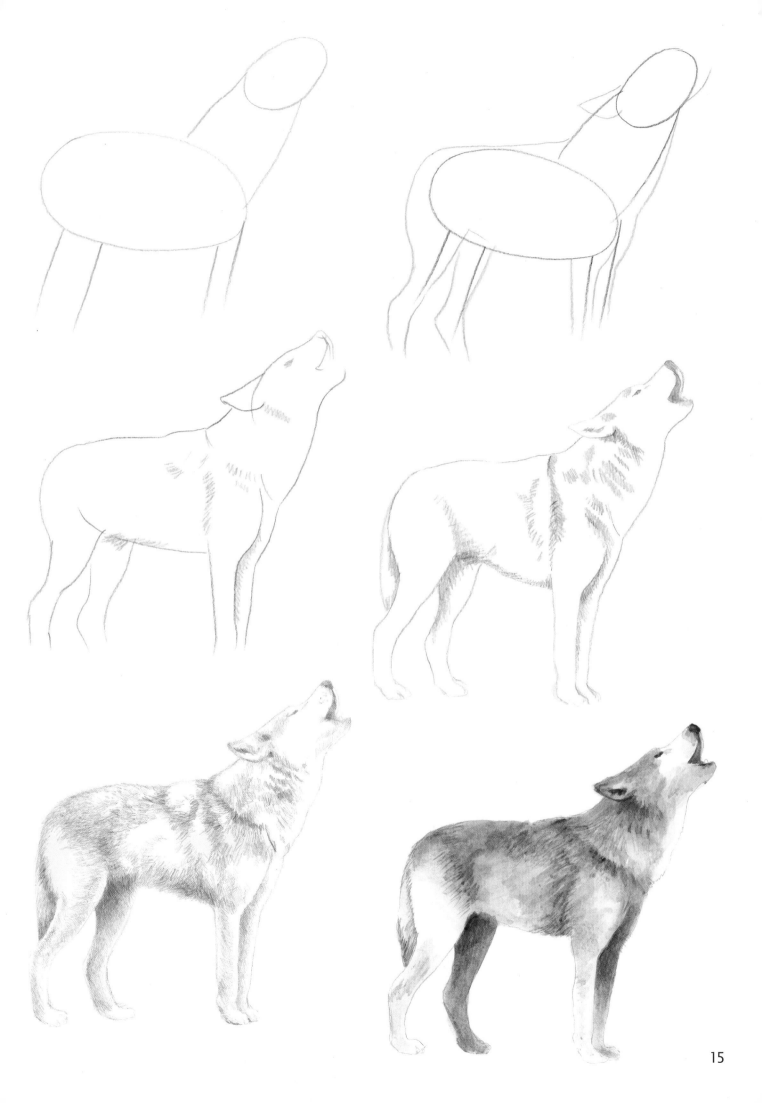

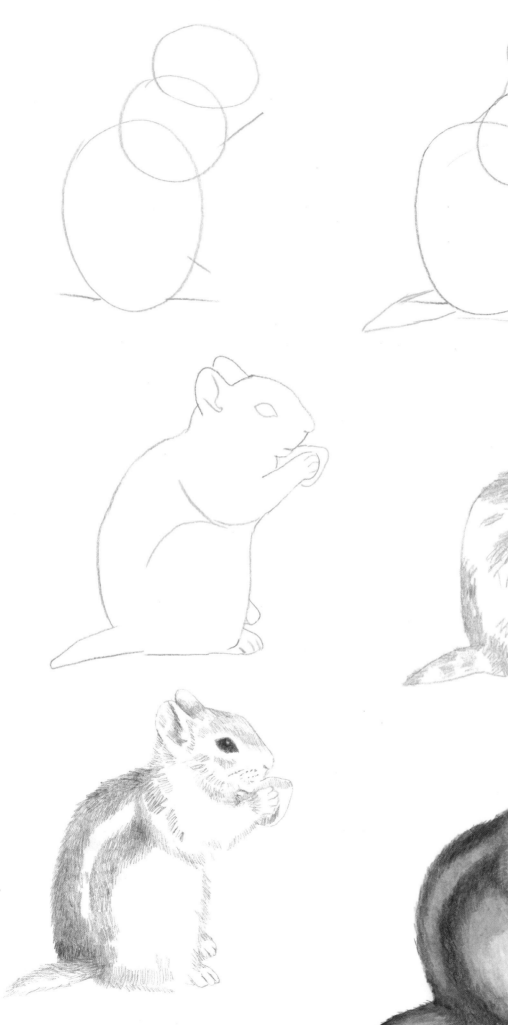
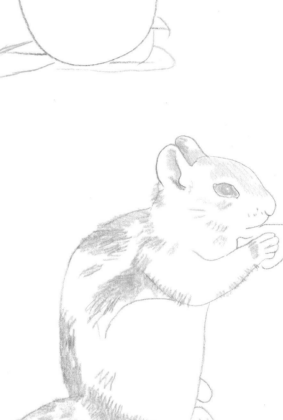
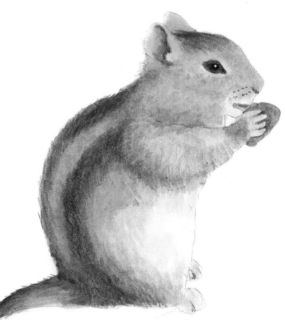

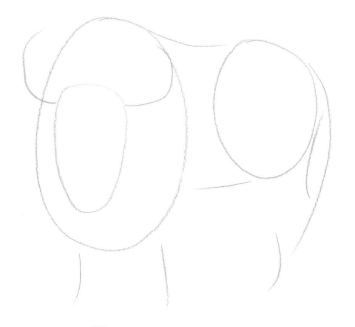
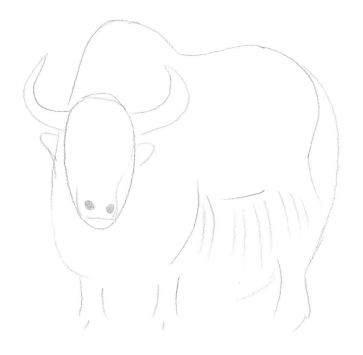
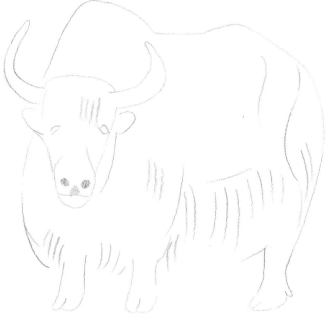
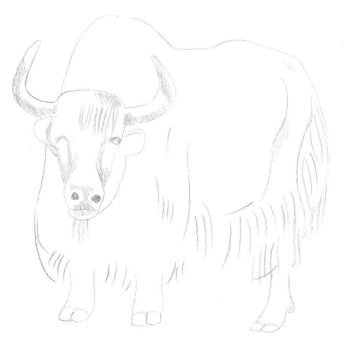
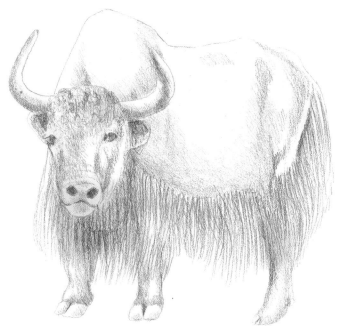
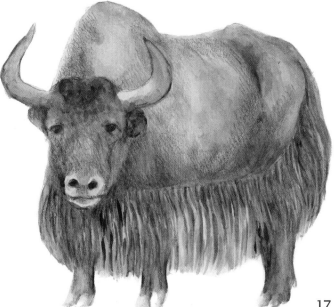

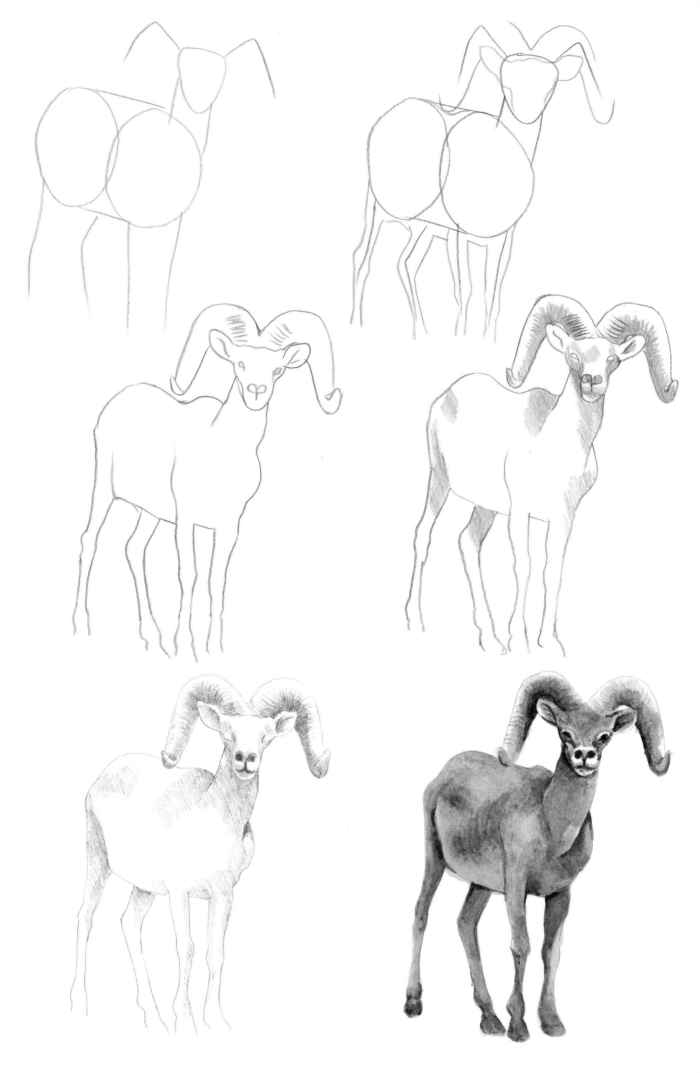

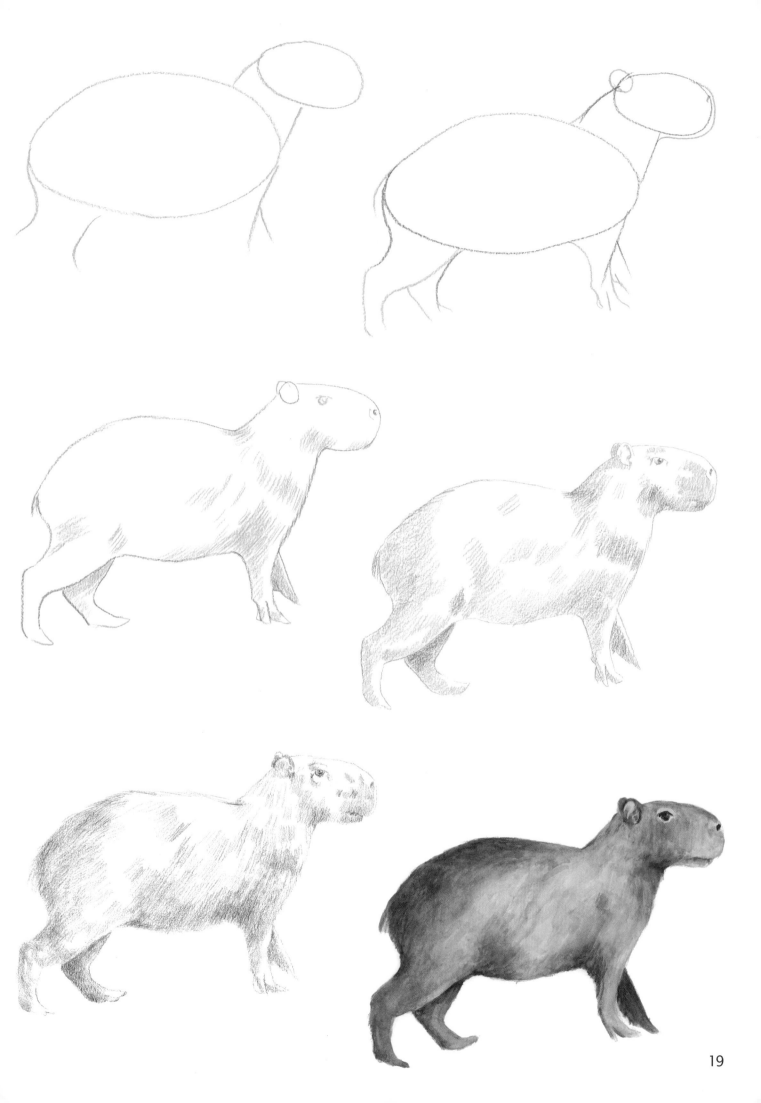

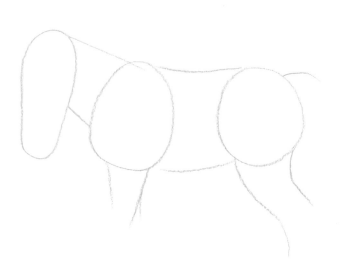

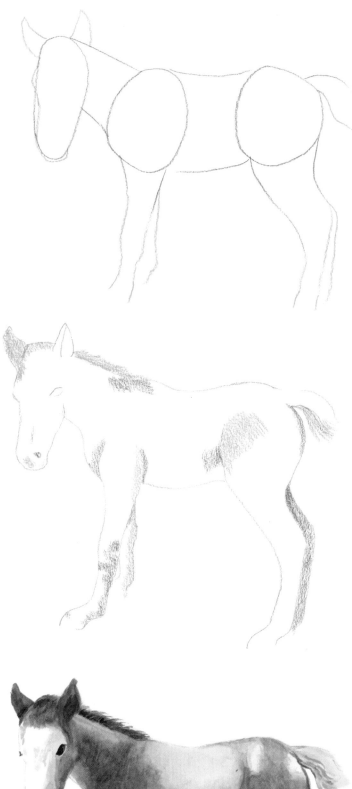

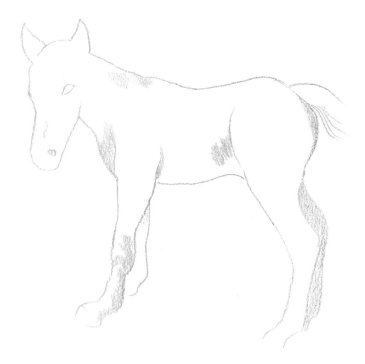

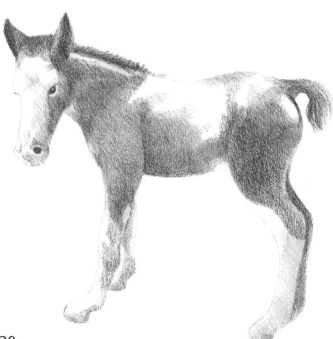

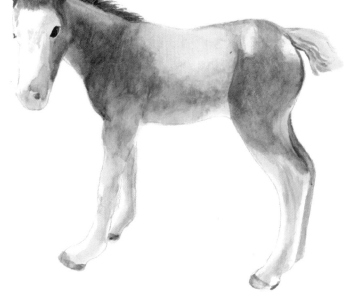

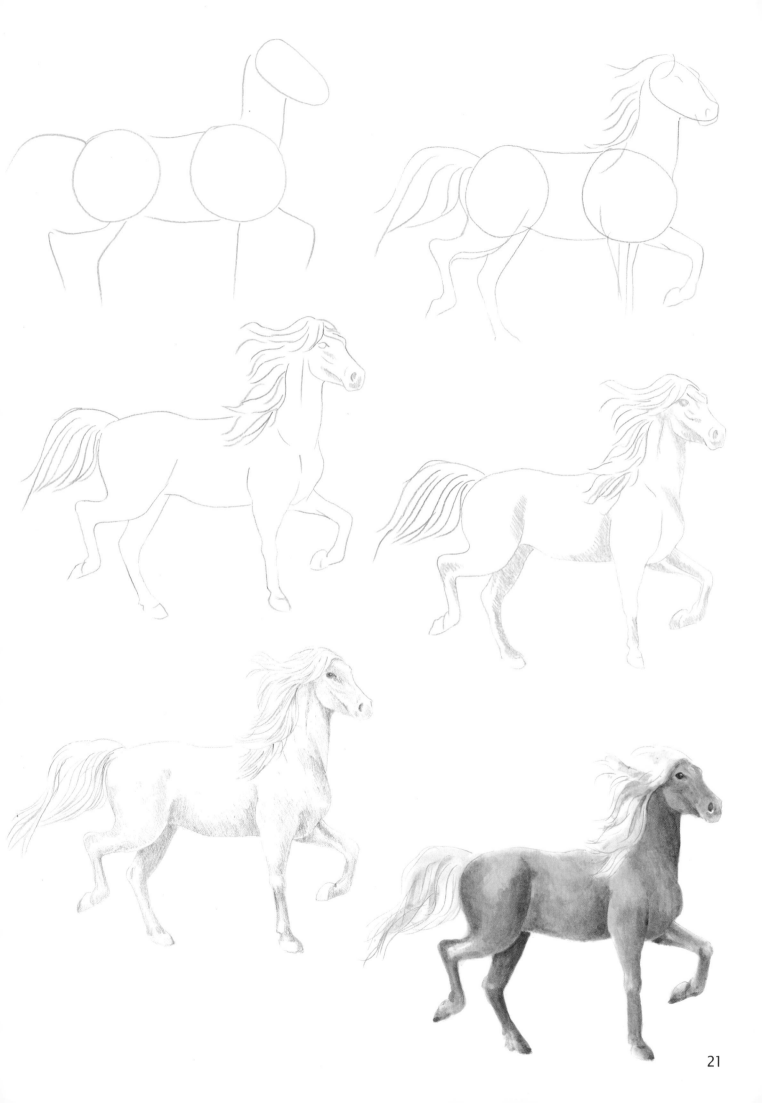

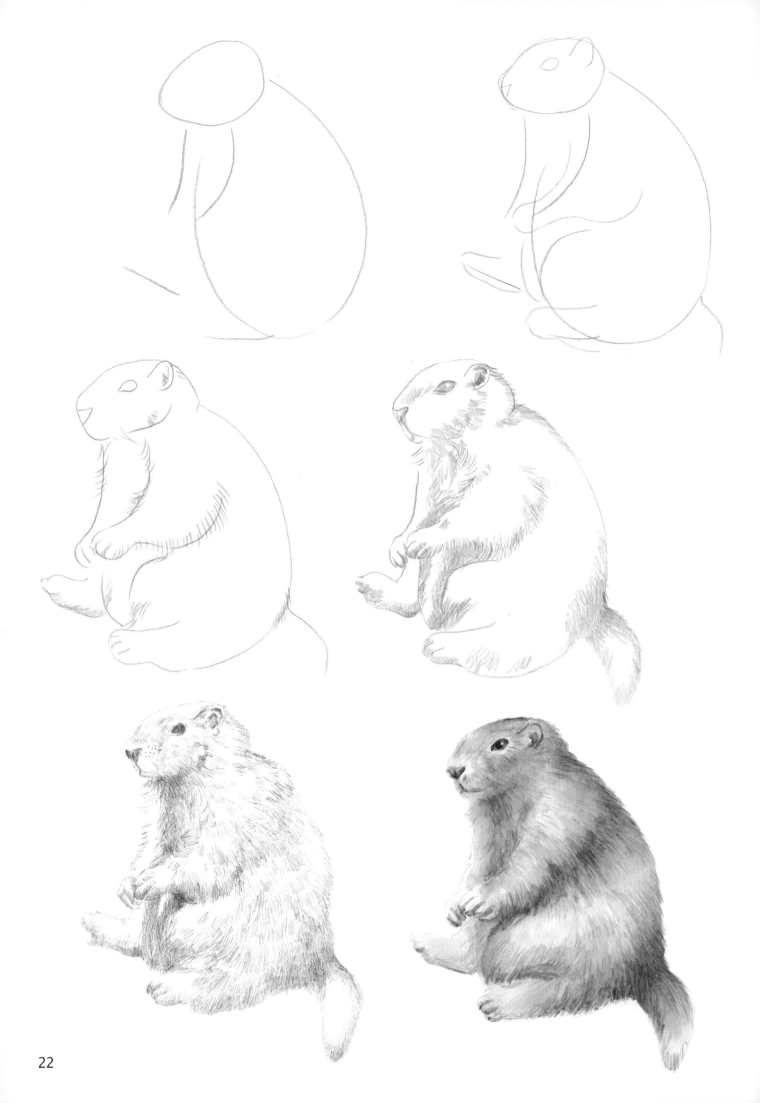

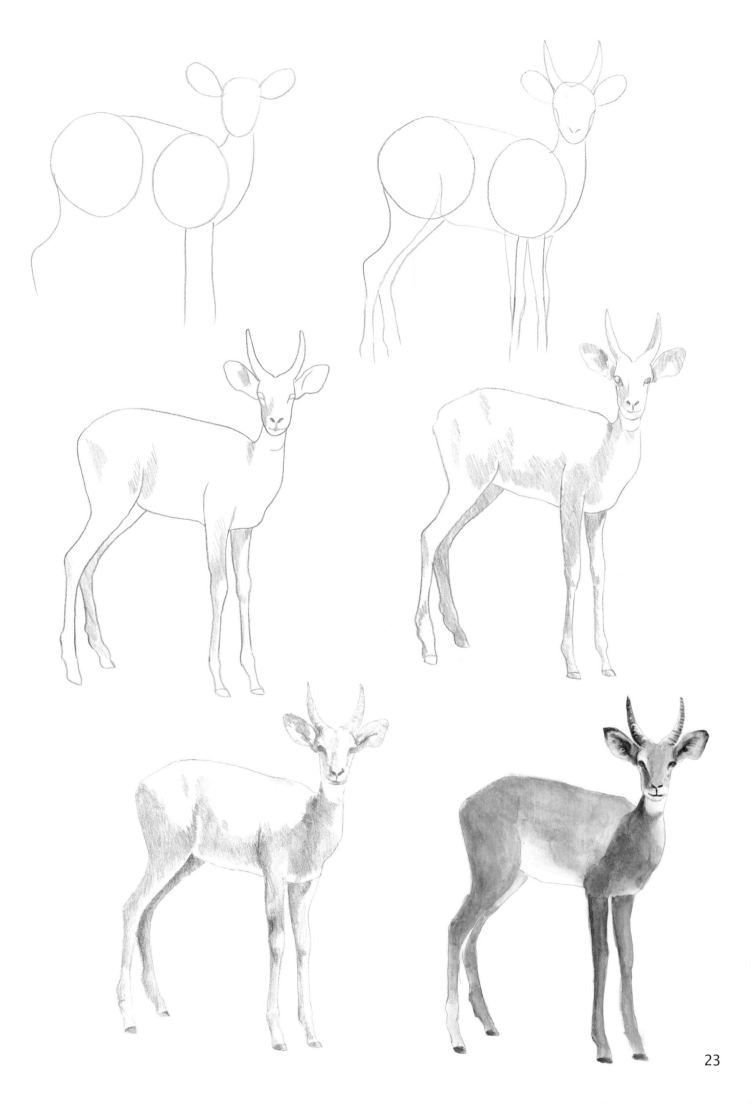

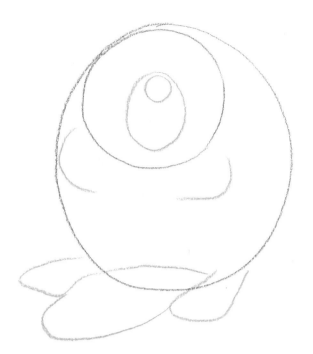

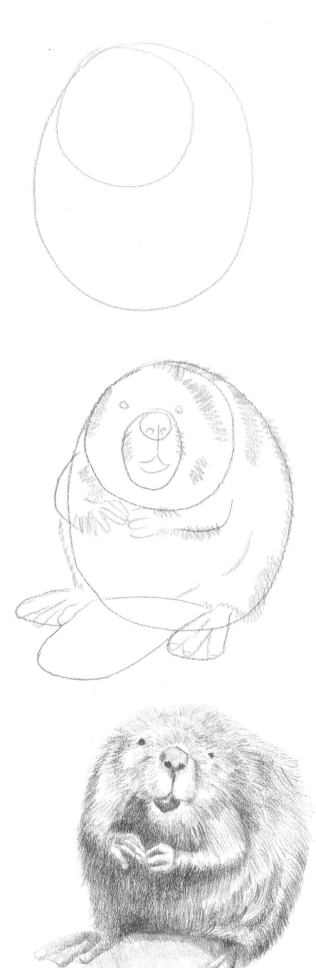

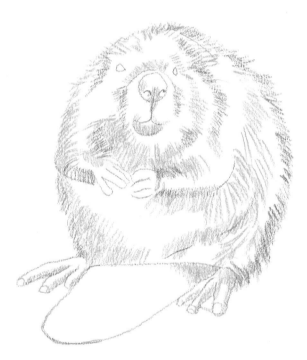

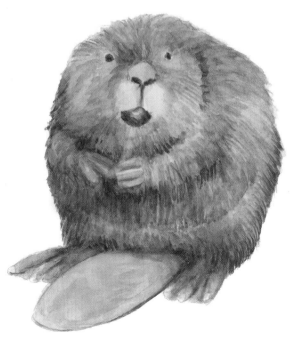

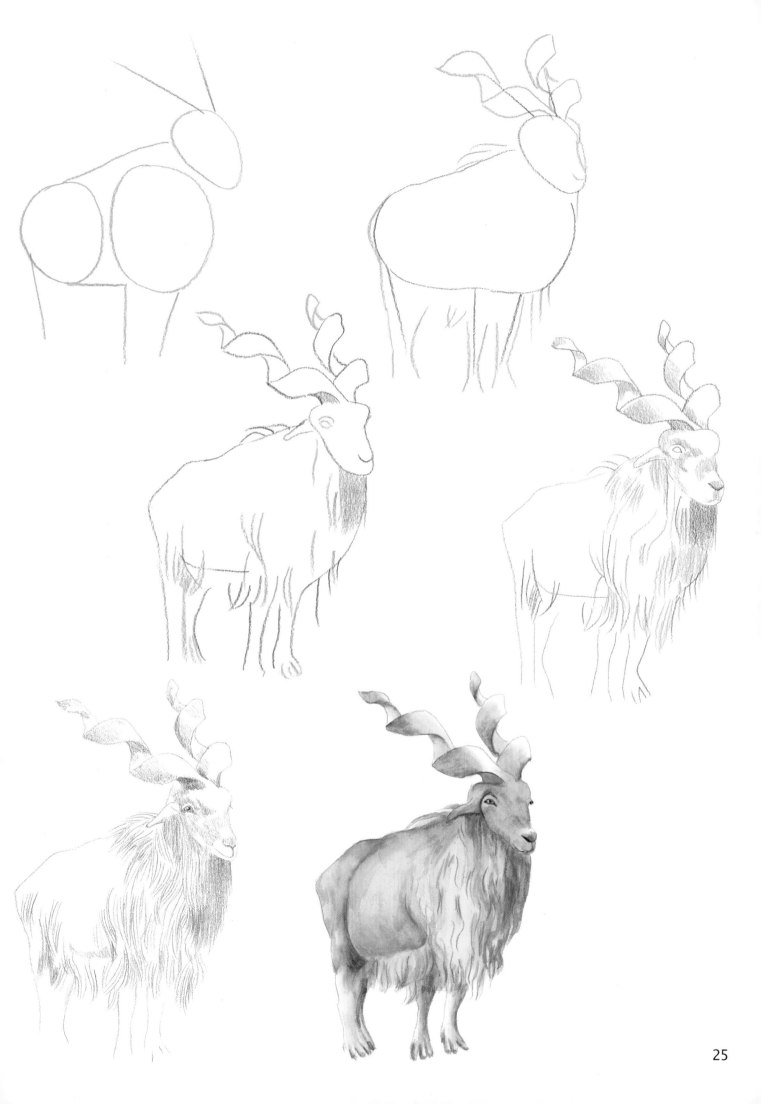

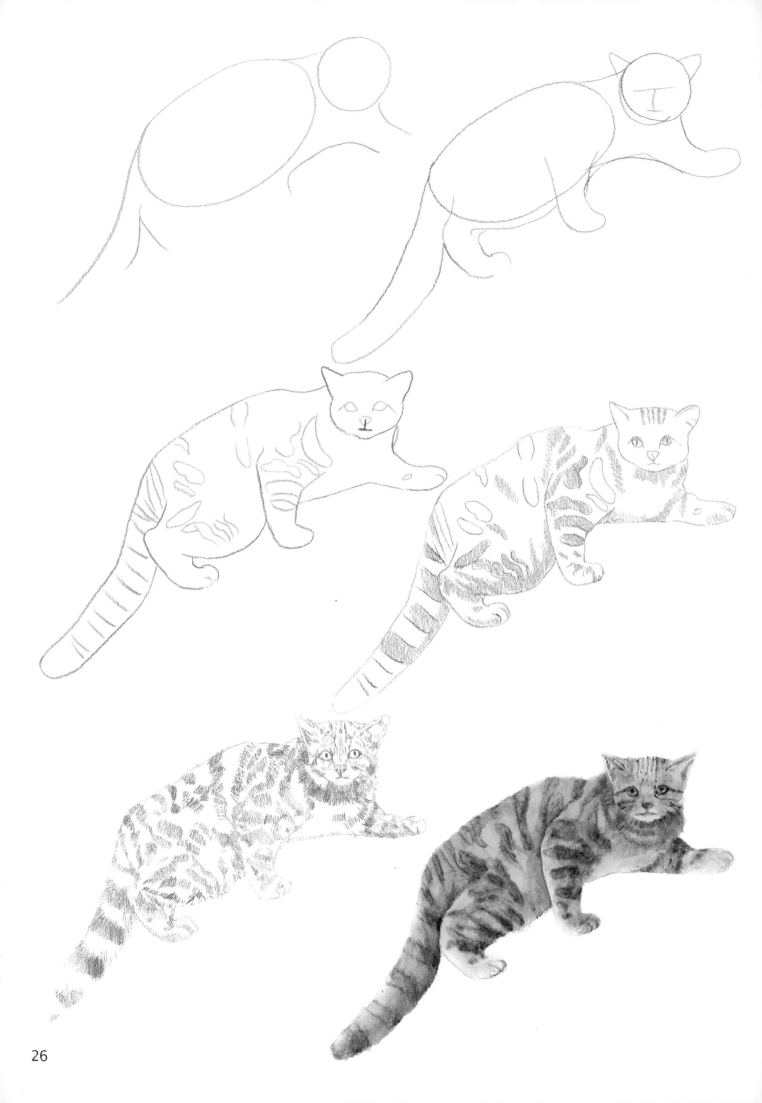

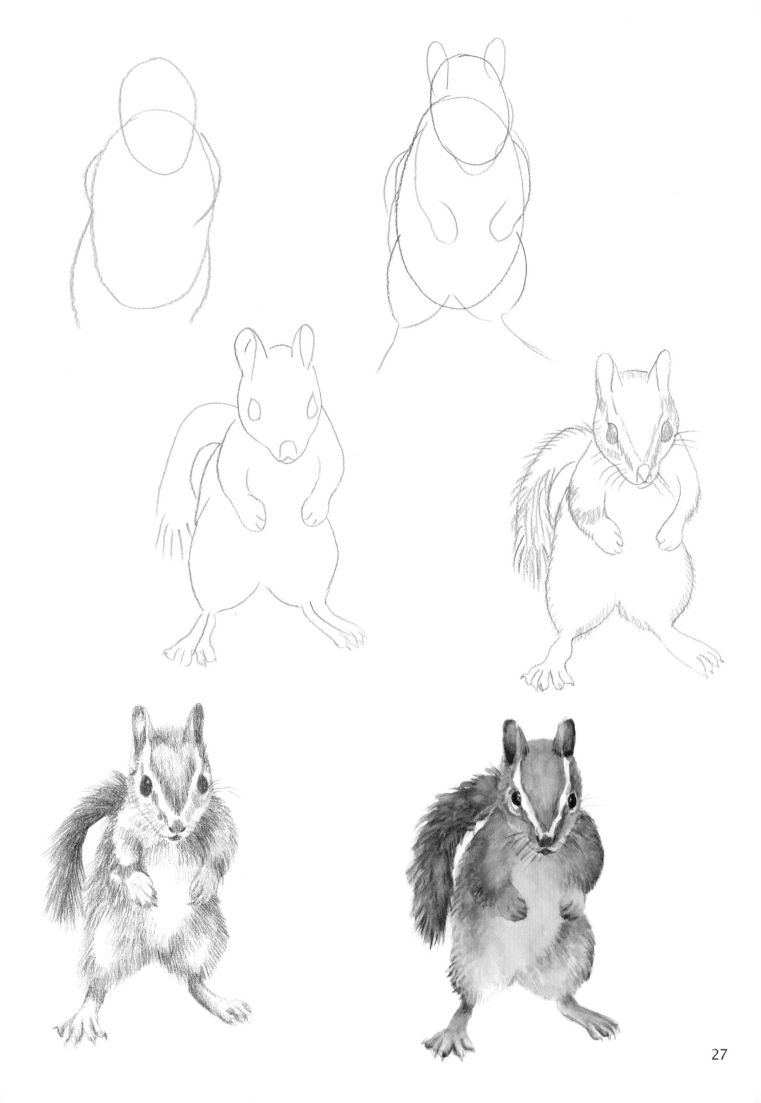

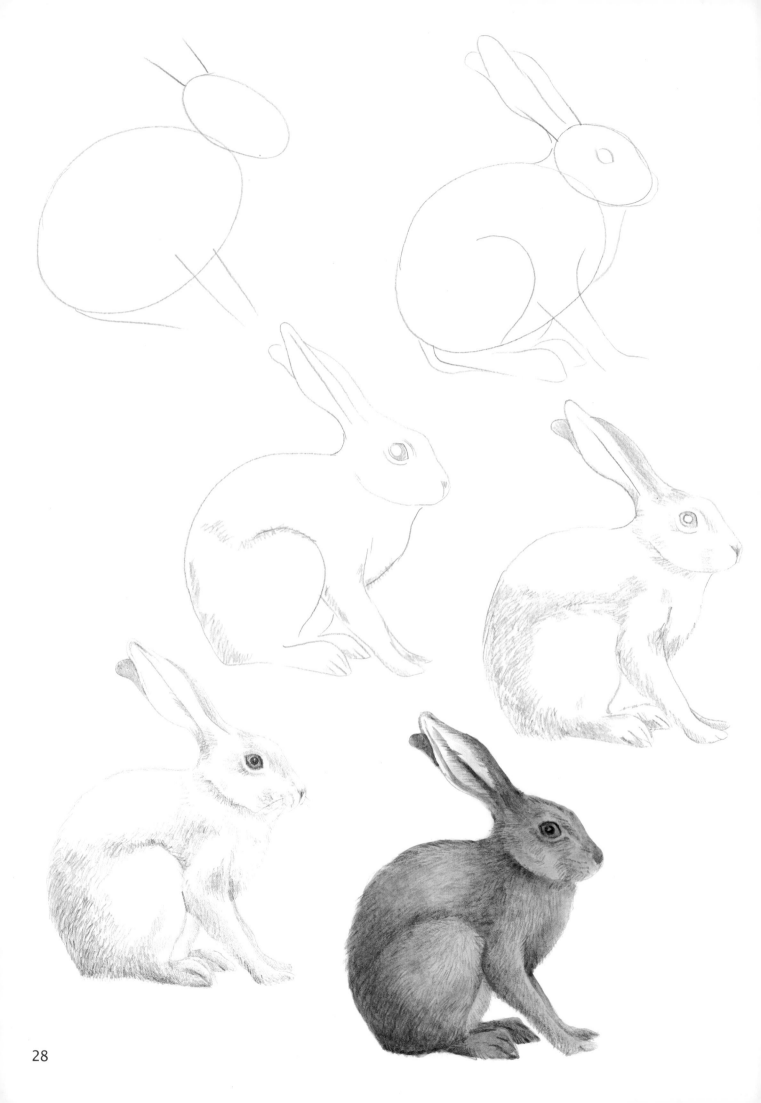

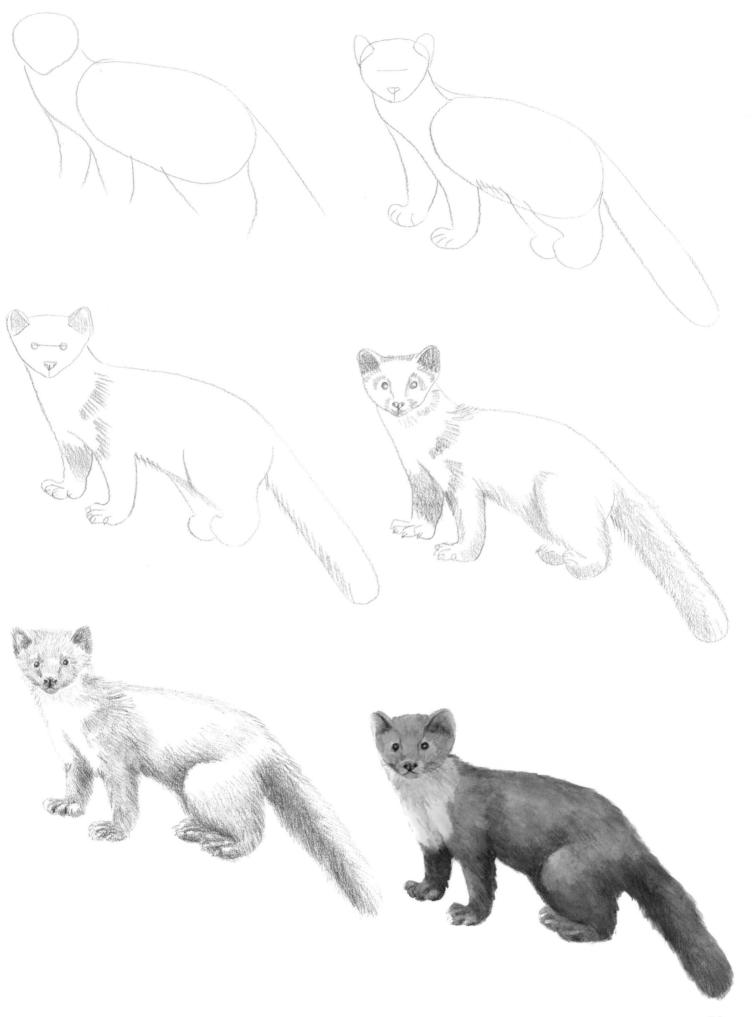

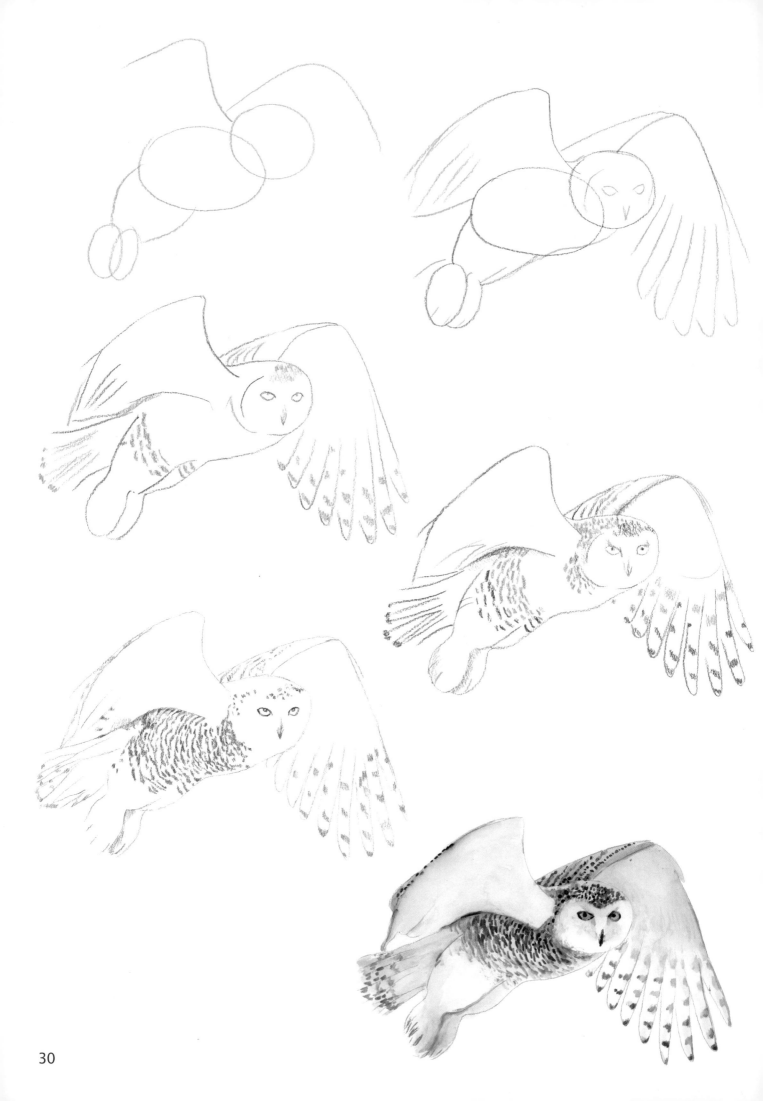

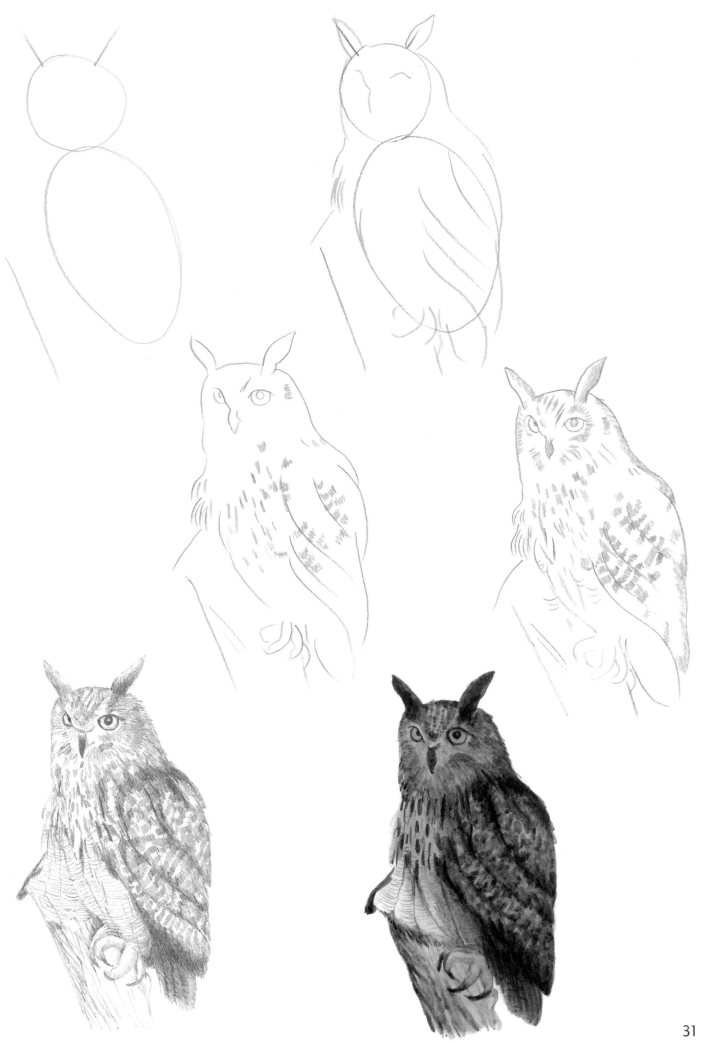

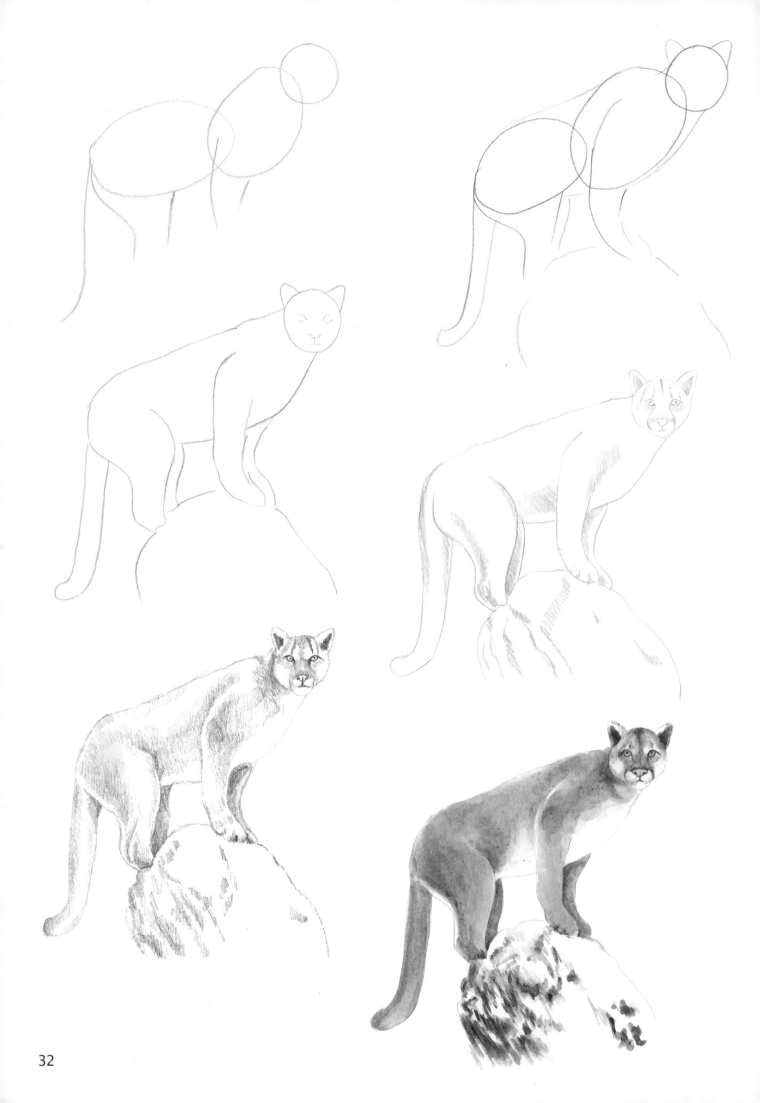